Color Your Own

GREAT PAINTINGS
BY WOMEN ARTISTS

Rendered by
MARTY NOBLE

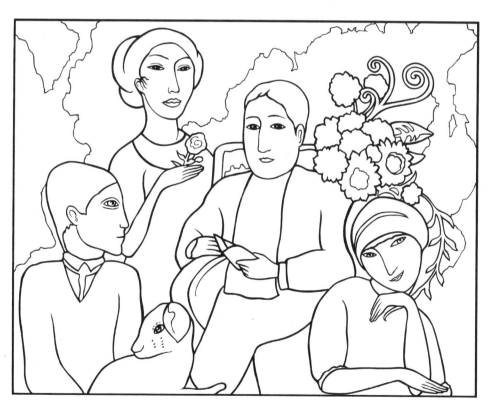

DOVER PUBLICATIONS, INC.
Mineola, New York

NOTE

Covering a wide range of art styles and movements, the outstanding paintings in this book are representative of some of the finest works executed by women over the past four centuries. Showcasing the talents of thirty different female artists, these black-and-white line renderings are arranged alphabetically by the artist's name. All thirty of the paintings in this book are shown in full color on the inside front and back covers. Use this color scheme as a guide to create your own adaptation or change the colors to see the effects of color and tone on each painting. Captions identify the artist and title of the work, date of composition, medium employed, and the size of the original painting.

Bibliographical Note

Color Your Own Great Paintings by Women Artists is a new work, first published by Dover Publications, Inc., in 2006.

International Standard Book Number
ISBN-13: 978-0-486-45108-4
ISBN-10: 0-486-45108-9

Manufactured in the United States by Courier Corporation
45108903
www.doverpublications.com

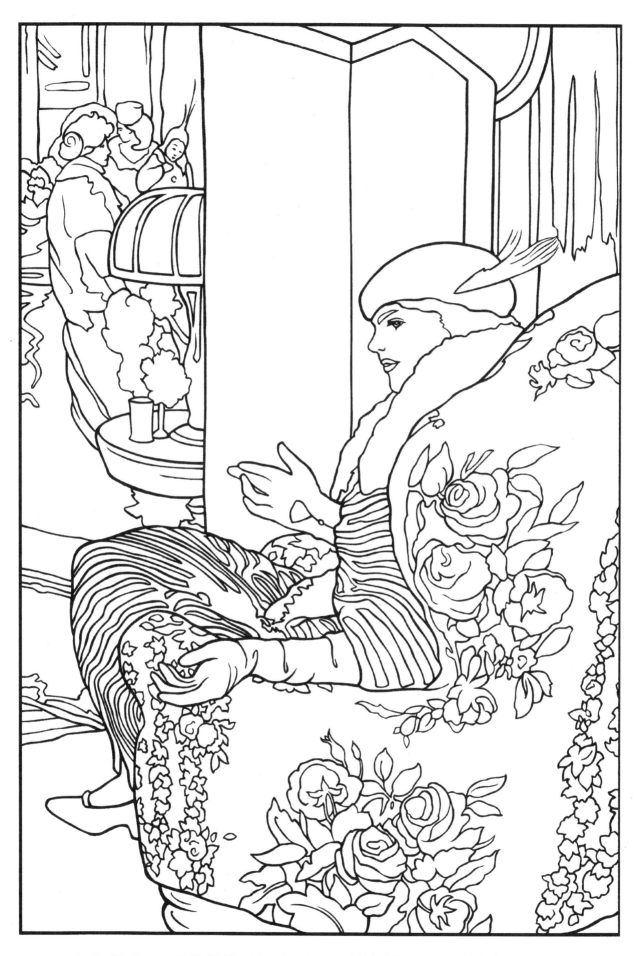

1. **Cecilia Beaux** (1855–1942). *After the Meeting,* 1914. Oil on canvas. 40¹⁵⁄₁₆ in. x 28⅛ in.

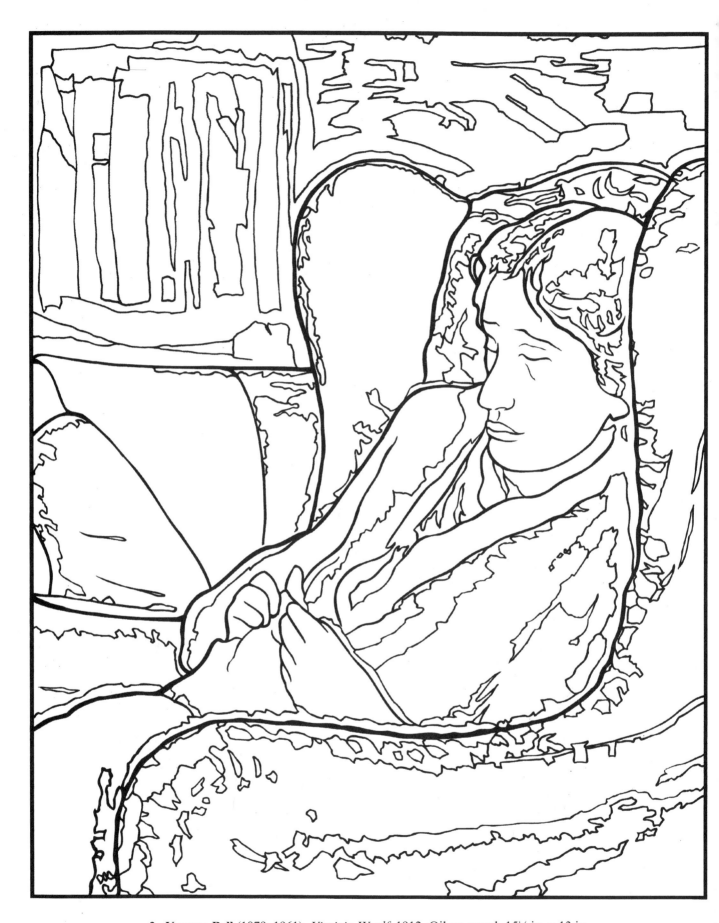

2. **Vanessa Bell** (1879–1961). *Virginia Woolf,* 1912. Oil on panel. 15½ in. x 13 in.

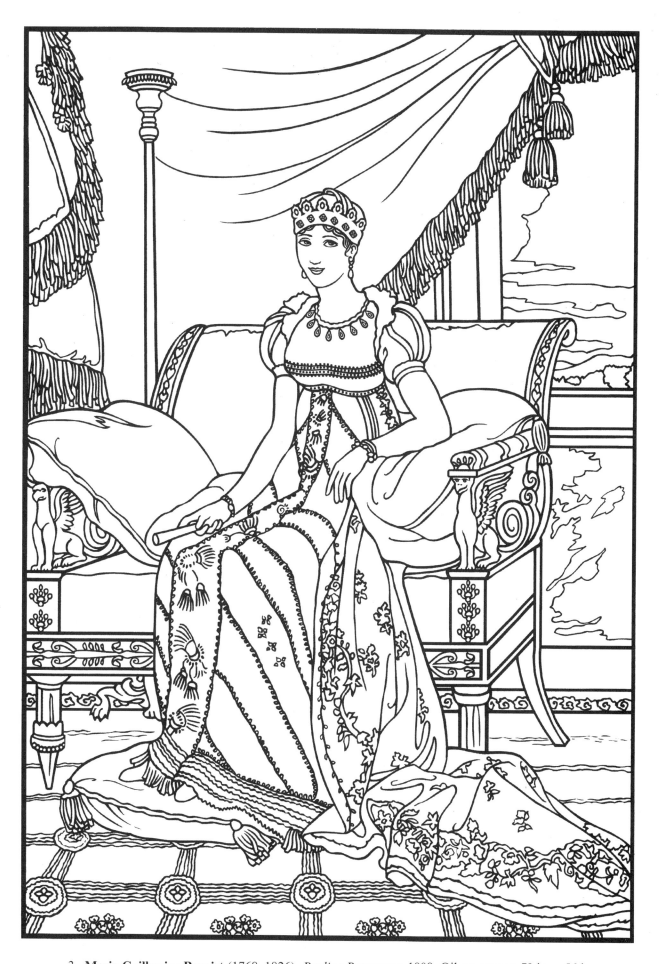

3. **Marie-Guillemine Benoist** (1768–1826). *Pauline Bonaparte,* 1808. Oil on canvas. 79 in. x 56 in.

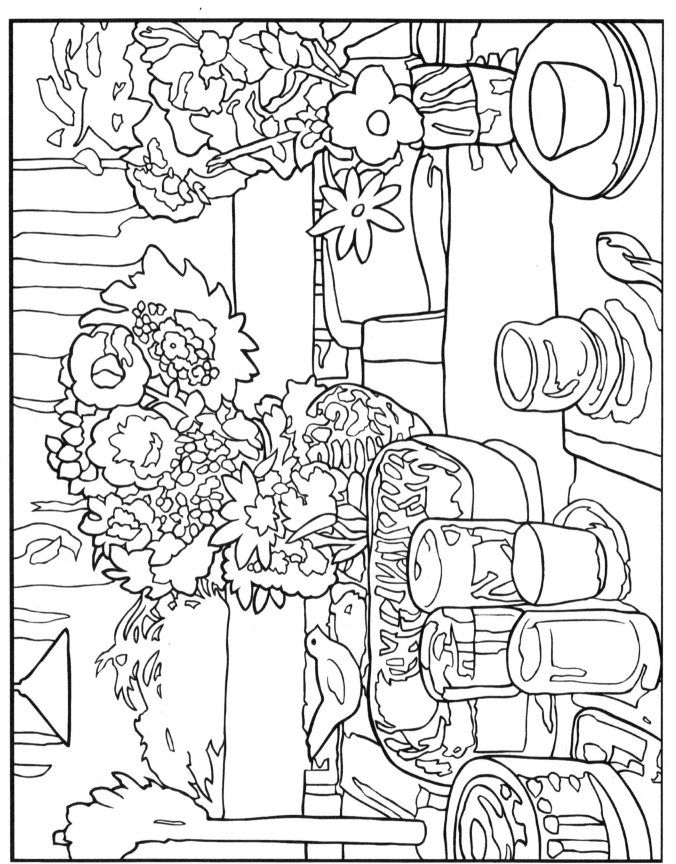

4. **Nell Blaine** (1922–1996). *Table with Flowers and Yellow Bird*, 1981. Oil on canvas. 28 in. x 32 in.

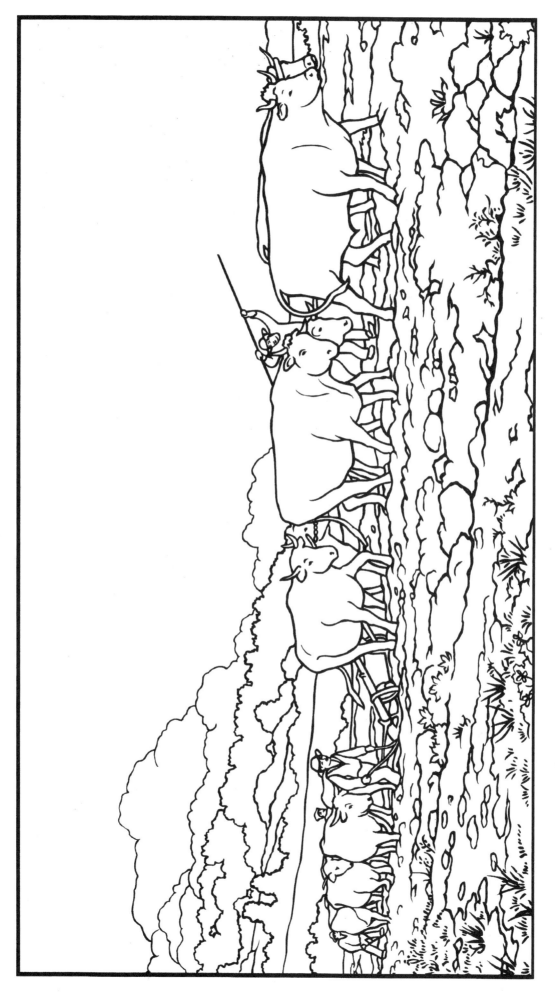

5. **Rosa Bonheur** (1822–1899). *Plowing in the Nivernais*, 1849. Oil on canvas. 69 in. x 104 in.

6. **Marie Bracquemond** (1841–1916). *On the Terrace at Sèvres*, 1880. Oil on canvas. 34½ in. x 45 in.

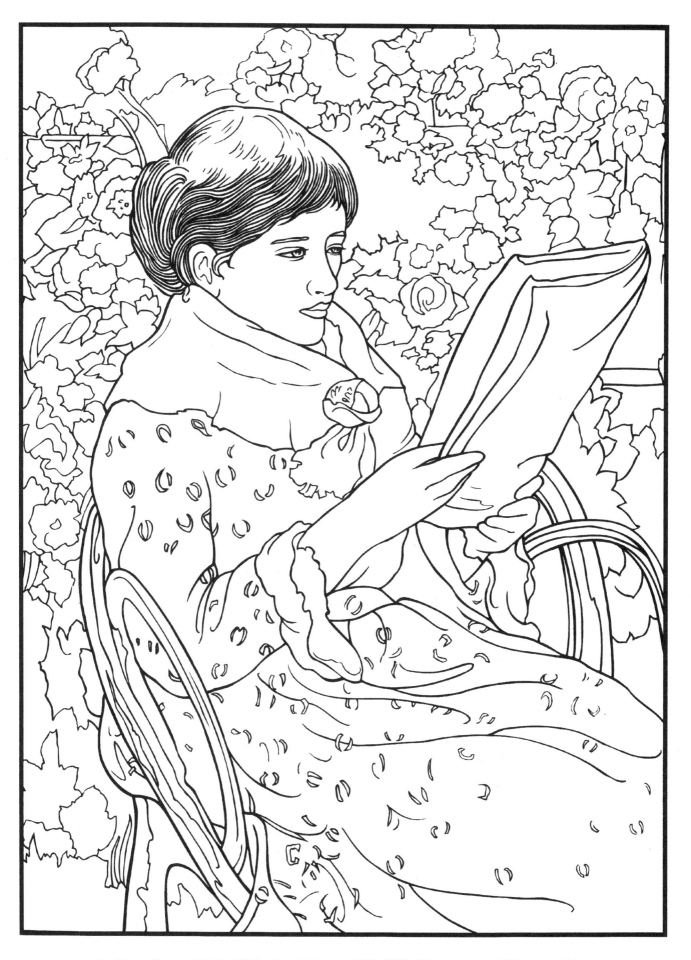

7. **Mary Cassatt** (1844–1926). *On a Balcony,* 1878–1879. Oil on canvas. 35⅜ in. x 25⅝ in.

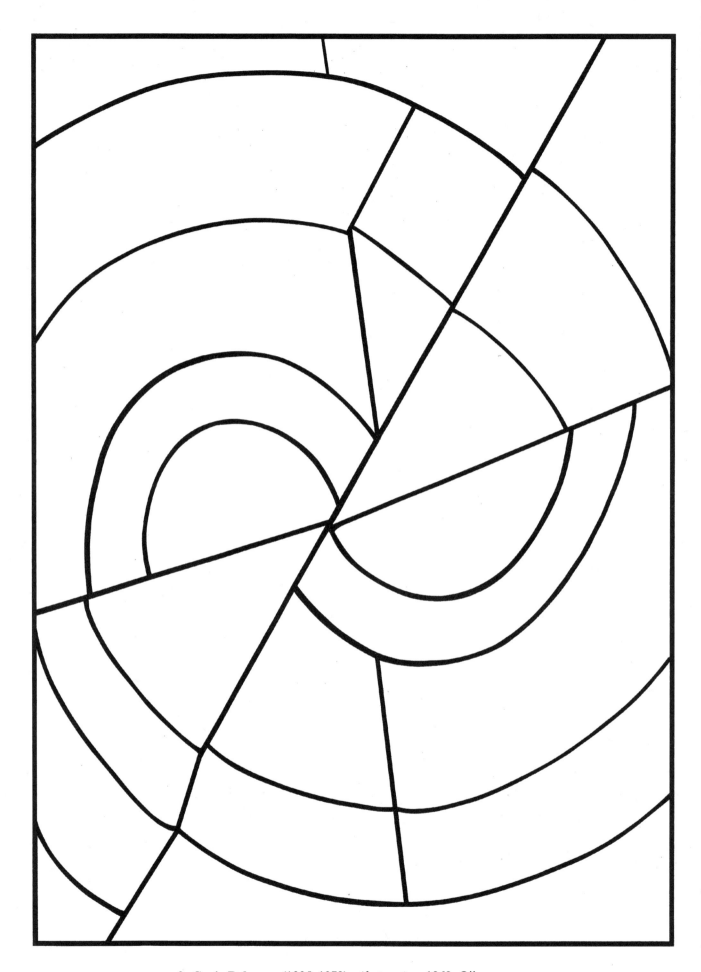

8. **Sonia Delaunay** (1885–1979). *Abstraction,* 1969. Oil on canvas.

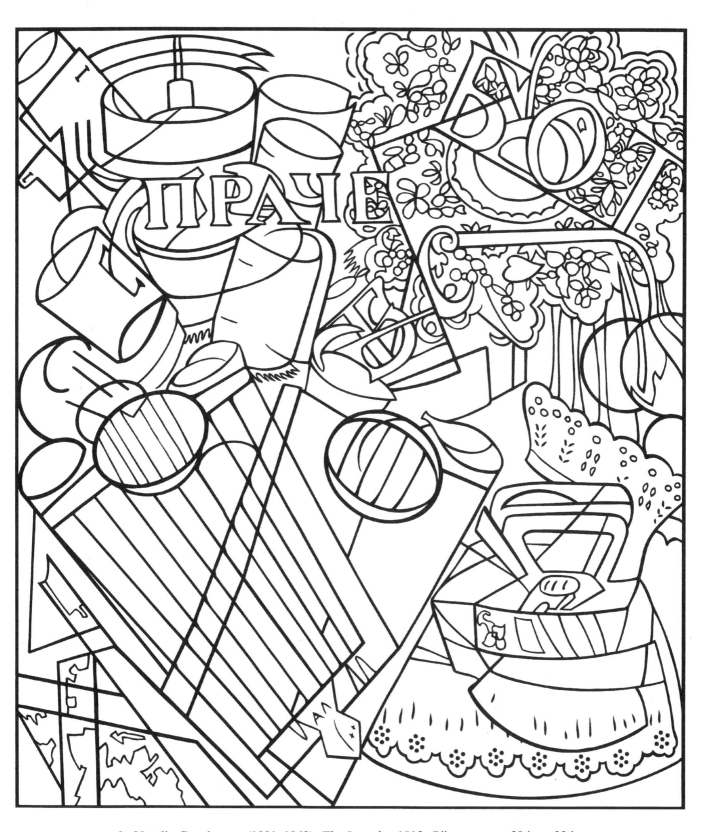

9. **Natalia Goncharova** (1881–1962). *The Laundry,* 1912. Oil on canvas. 38 in. x 33 in.

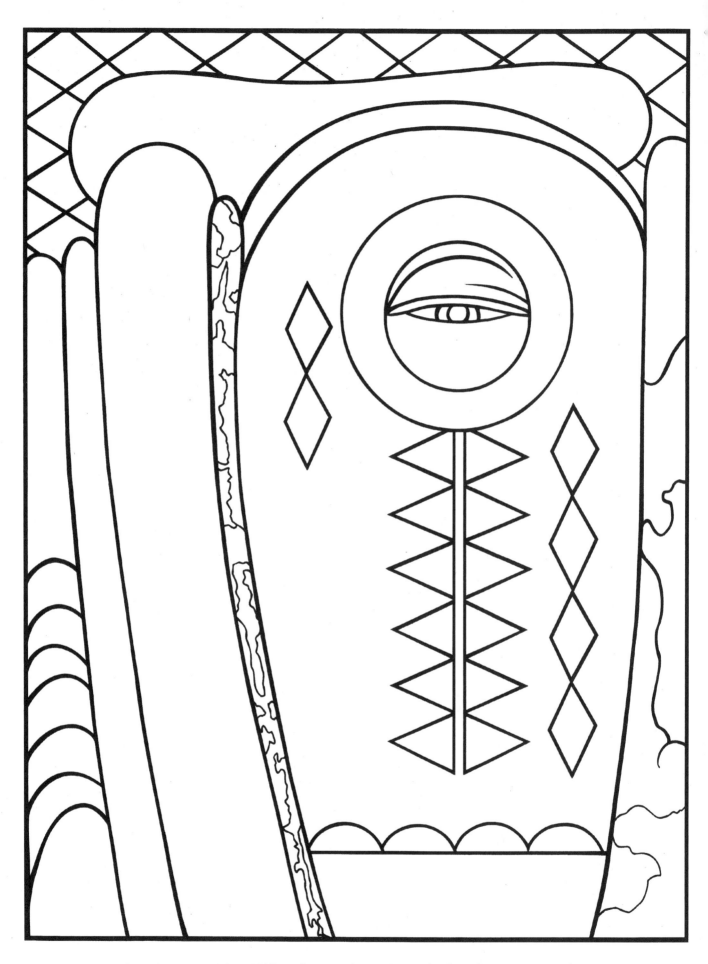

10. **Lois Mailou Jones** (1905–1998). *Ode to Kinshasa,* 1972. Mixed media on canvas. 48 in. x 36 in.

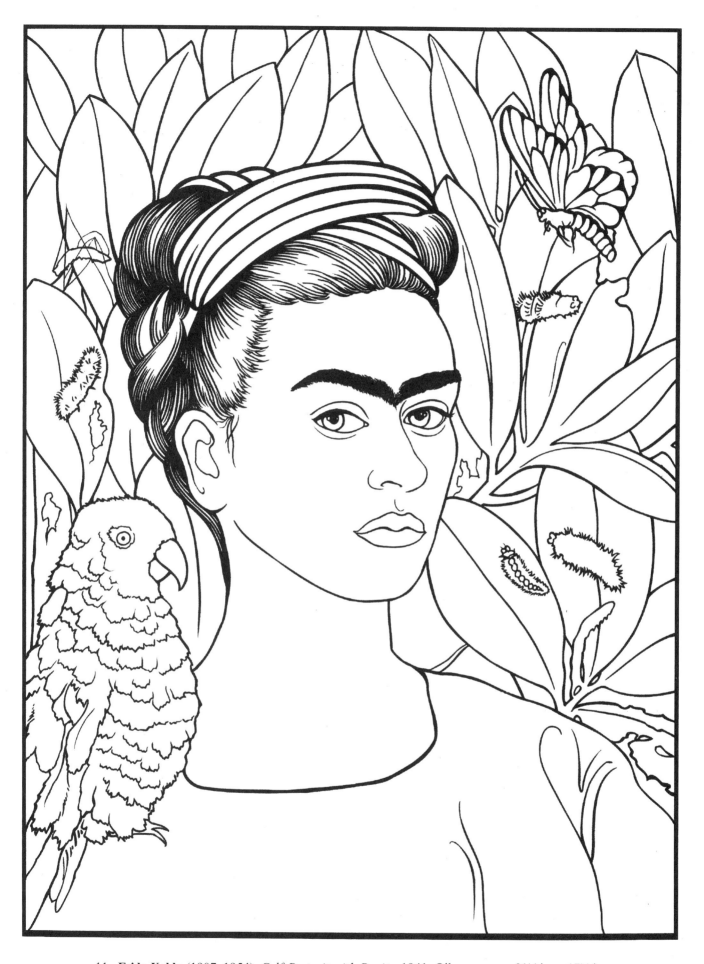

11. **Frida Kahlo** (1907–1954). *Self-Portrait with Bonito,* 1941. Oil on canvas. 21½ in. x 17⅛ in.

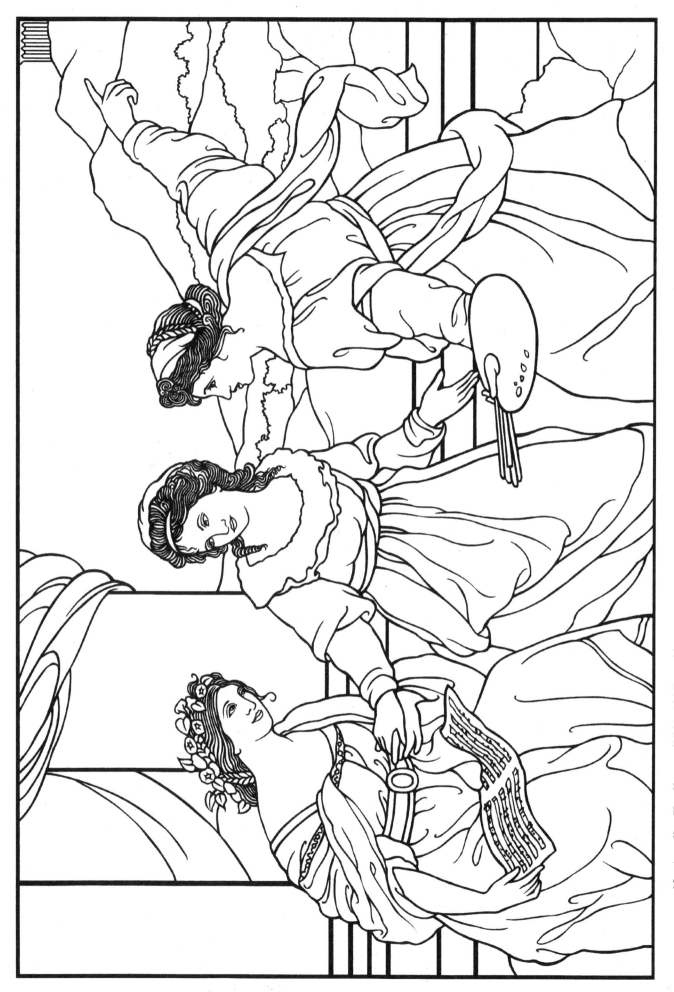

12. **Angelica Kauffmann** (1741–1807). *Self-Portrait Hesitating between the Arts of Music and Painting.* 1791. Oil on canvas. 58 in. x 85 in.

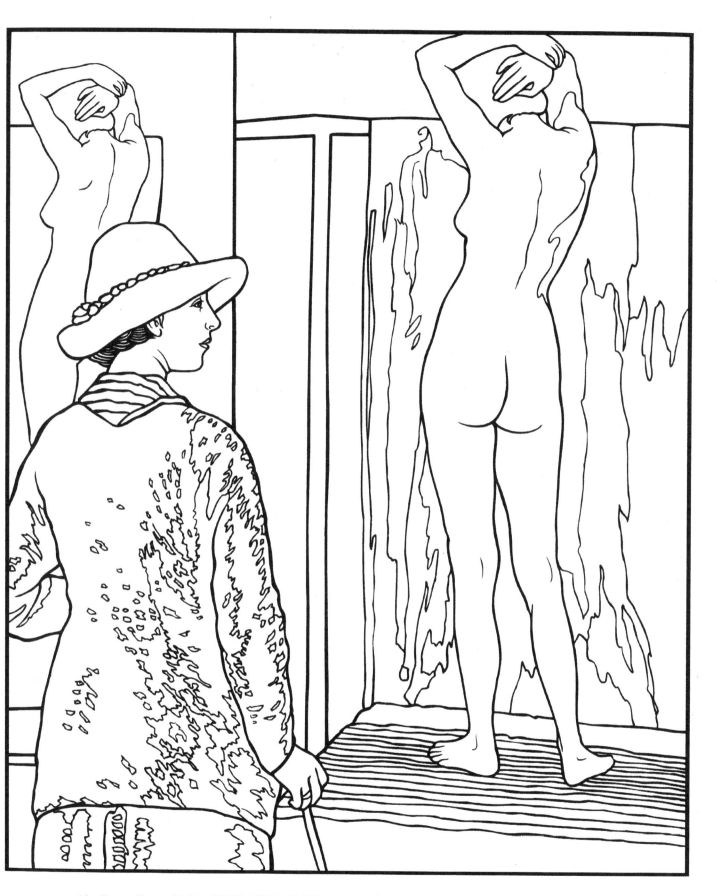

13. **Dame Laura Knight** (1877–1970). *Self-Portrait with Nude,* 1913. Oil on canvas. 60 in. x 50¼ in.

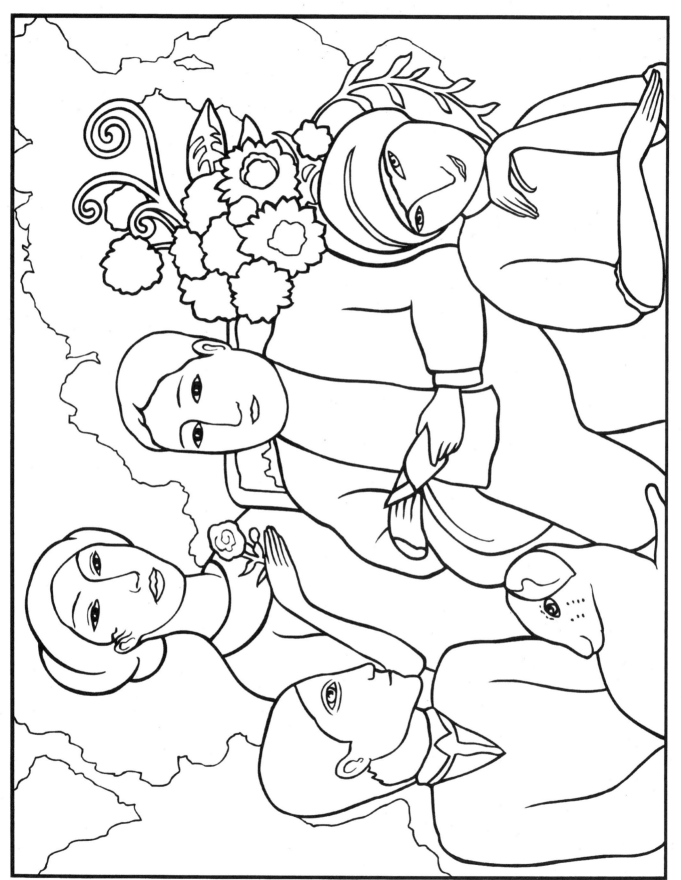

14. **Marie Laurencin** (1885–1956). *Group of Artists*, 1908. Oil on canvas. 24¾ in. x 31⅛ in.

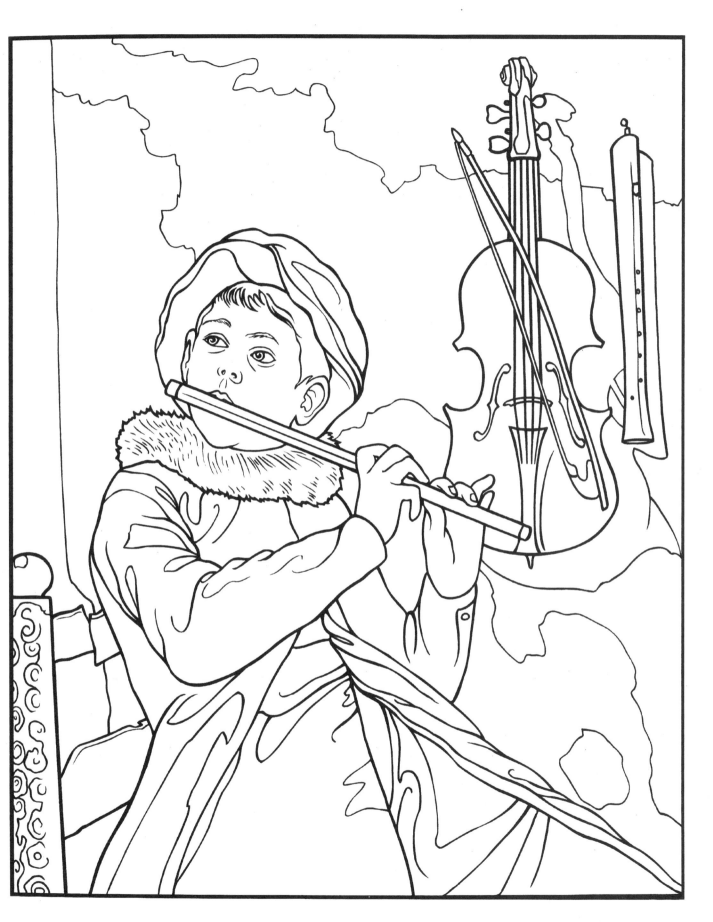

15. **Judith Leyster** (1609–1660). *The Flute Player*, n.d. Oil on canvas. 28½ in. x 24¼ in.

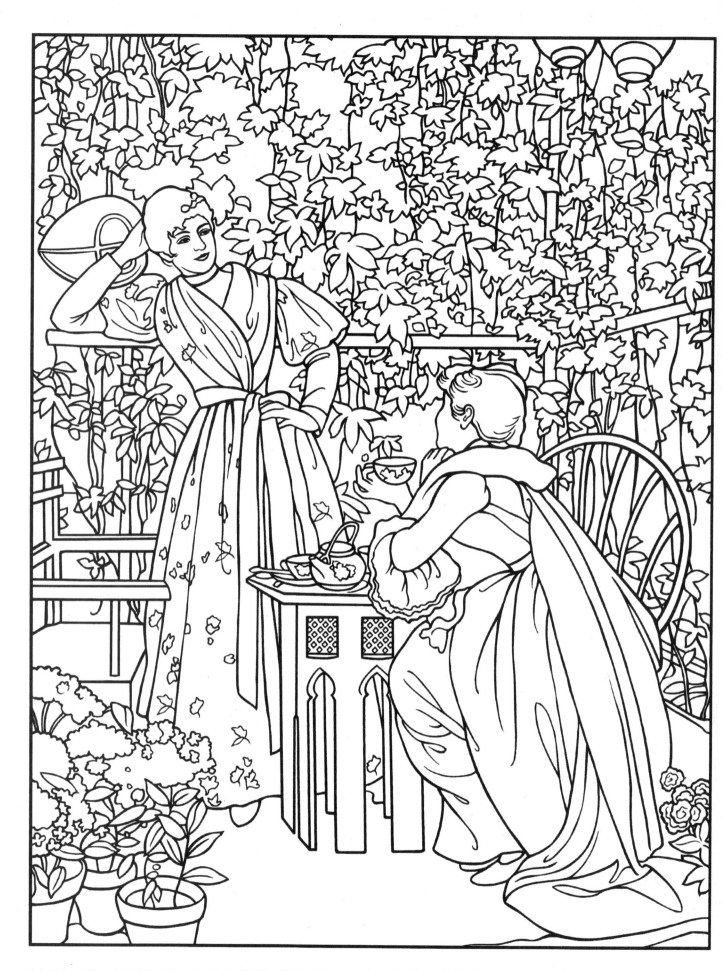

16. **Mary Fairchild MacMonnies Low** (1858–1946). *Between Friends (Five O'Clock Tea)*, 1891. Oil on canvas. 89 in. x 61 in.

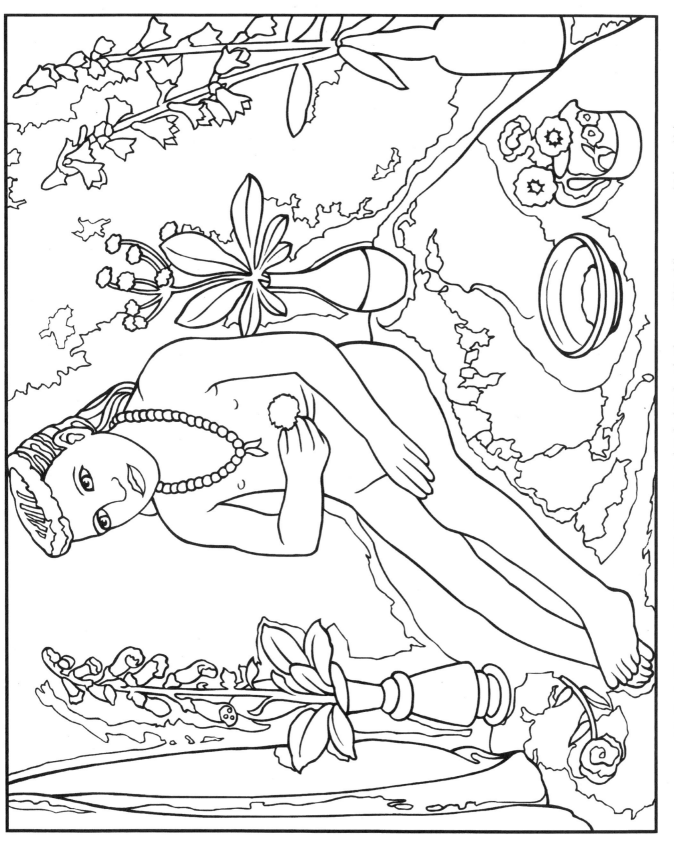

17. **Paula Modersohn-Becker** (1876–1907). *Seated Naked Girl with Flowers*, 1907. Oil on canvas. 35 in. x 43 in.

18. **Evelyn de Morgan** (1855–1919). *Love's Passing*, 1883–1884. Oil on canvas. 28¼ in. x 43¼ in.

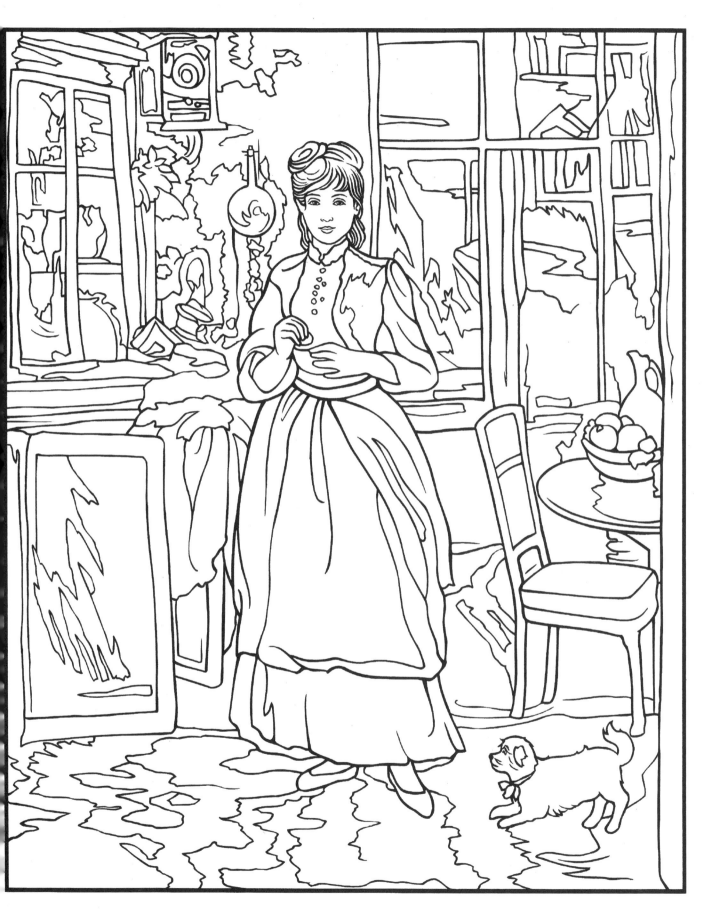

19. **Berthe Morisot** (1841–1895). *In the Dining Room,* 1886. Oil on canvas. 24⅛ in. x 19¾ in.

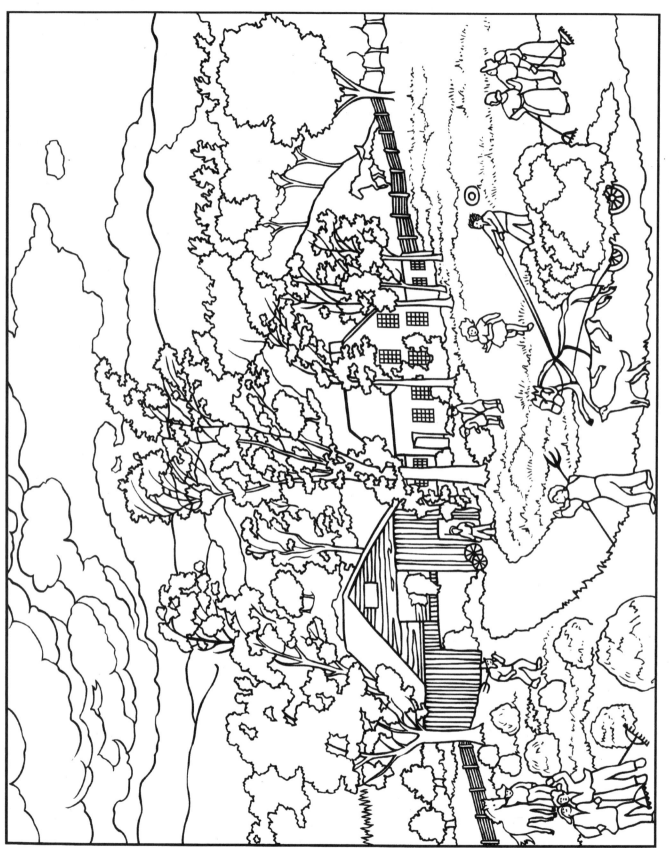

20. **Anna Mary Robertson ("Grandma") Moses** (1860–1961). *The Thunderstorm,* 1948. Oil on canvas. 20¾ in. x 24¾ in.

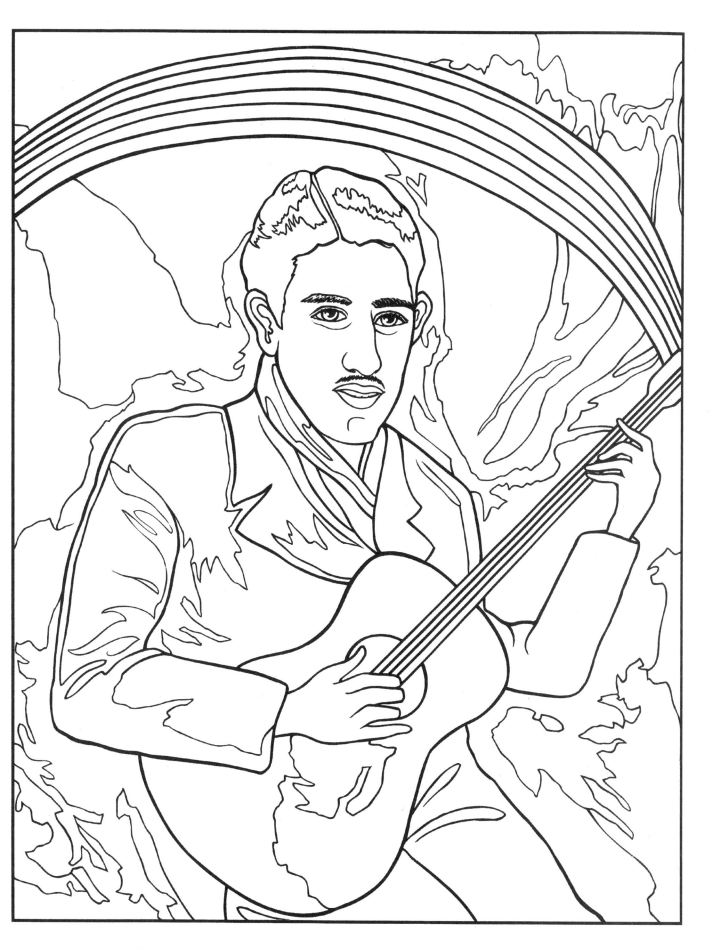

21. **Alice Neel** (1900–1984). *The Guitar Player,* 1936. Watercolor on paper. 14 in. x 11 in.

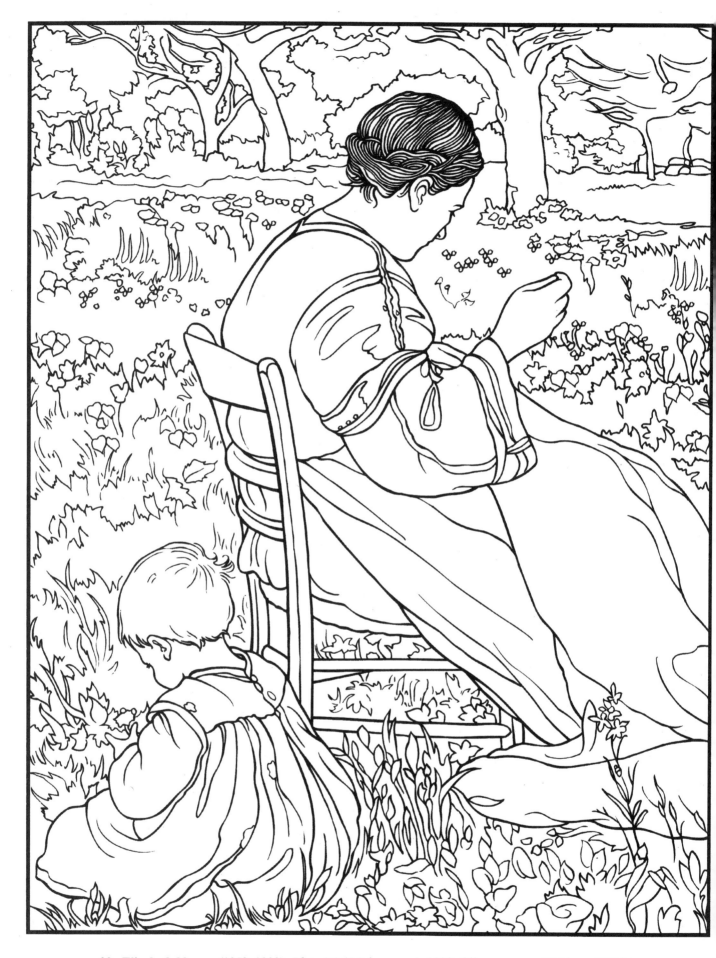

22. **Elizabeth Nourse** (1859–1938). *Plein été (Midsummer)*, 1898. Oil on canvas. 43⅛ in. x 31⅞ in.

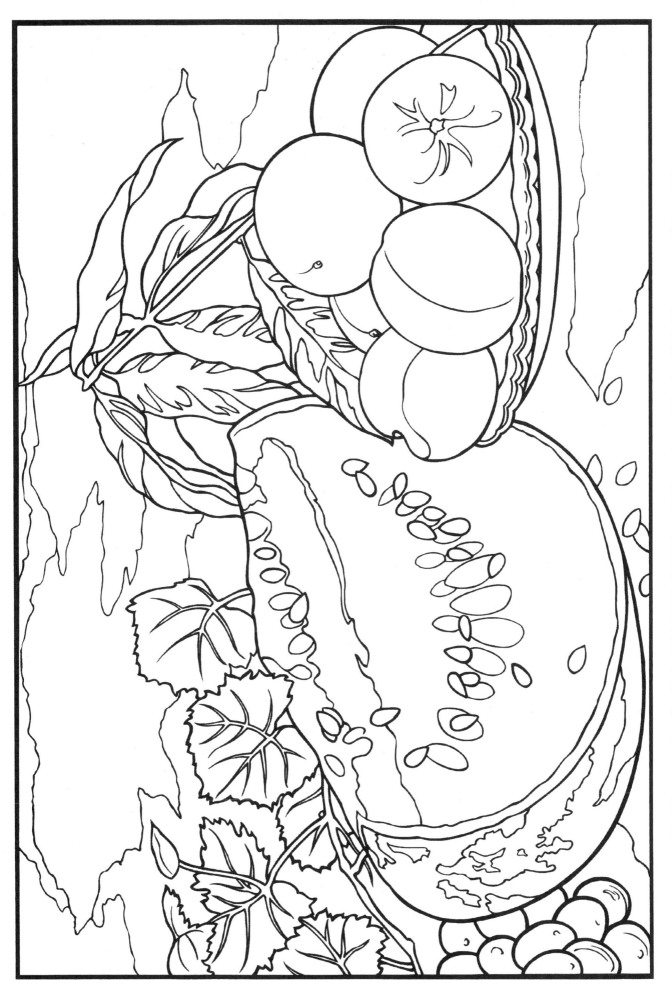

23. **Margaretta Angelica Peale** (1795–1882). *Still Life with Watermelon, and Peaches*, 1828. Oil on canvas. 13 in. x 19 in.

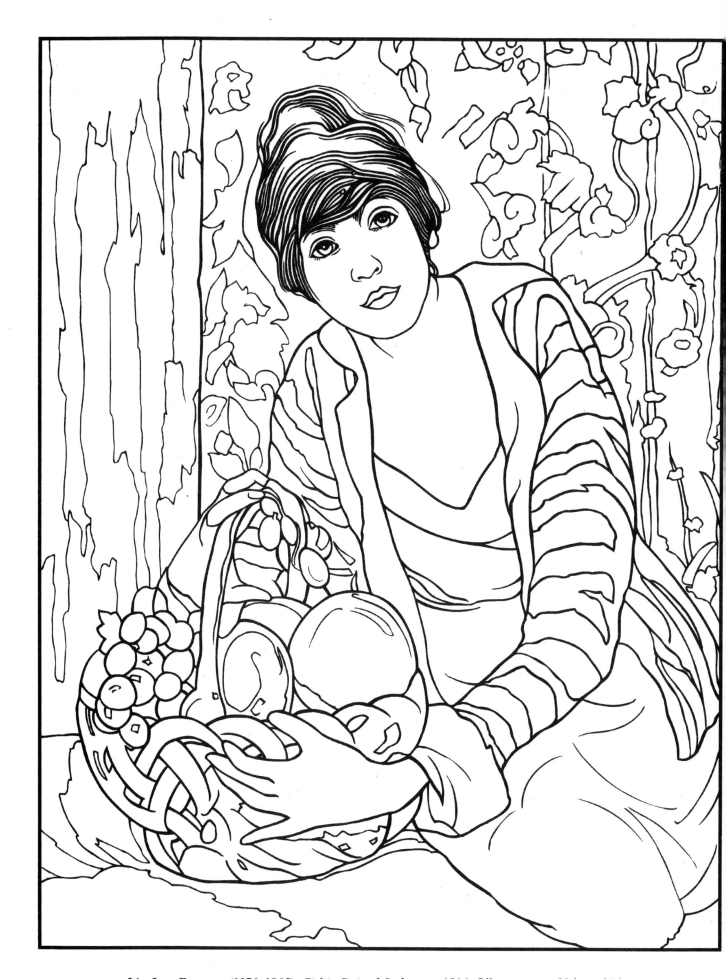

24. **Jane Peterson** (1876–1965). *Girl in Striped Jacket,* ca. 1914. Oil on canvas. 30 in. x 24 in.

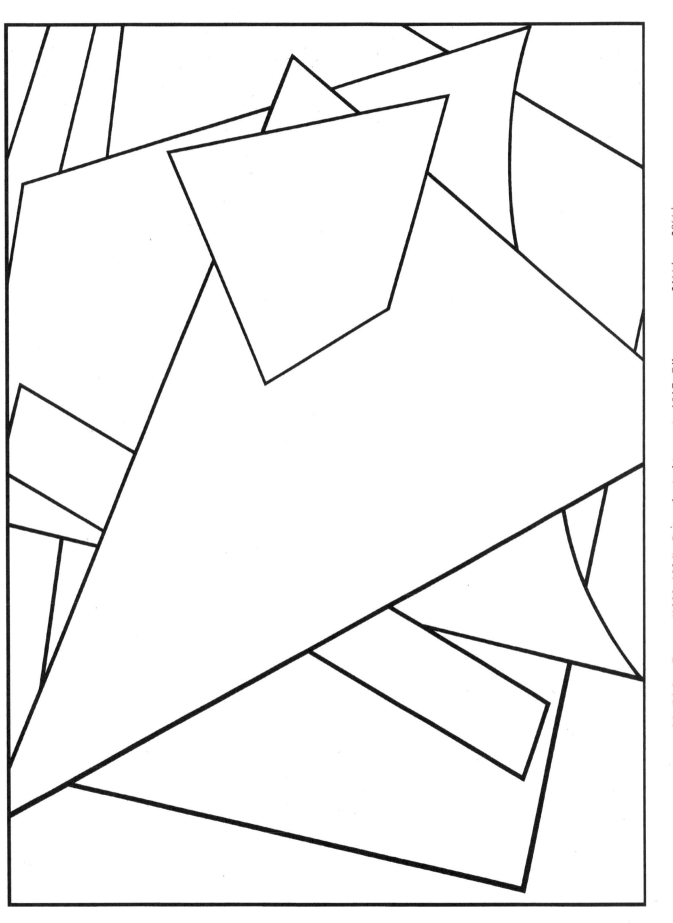

25. **Liubov Popova** (1889–1924). *Painterly Architectonic*, 1917. Oil on canvas. 31½ in. x 38⅝ in.

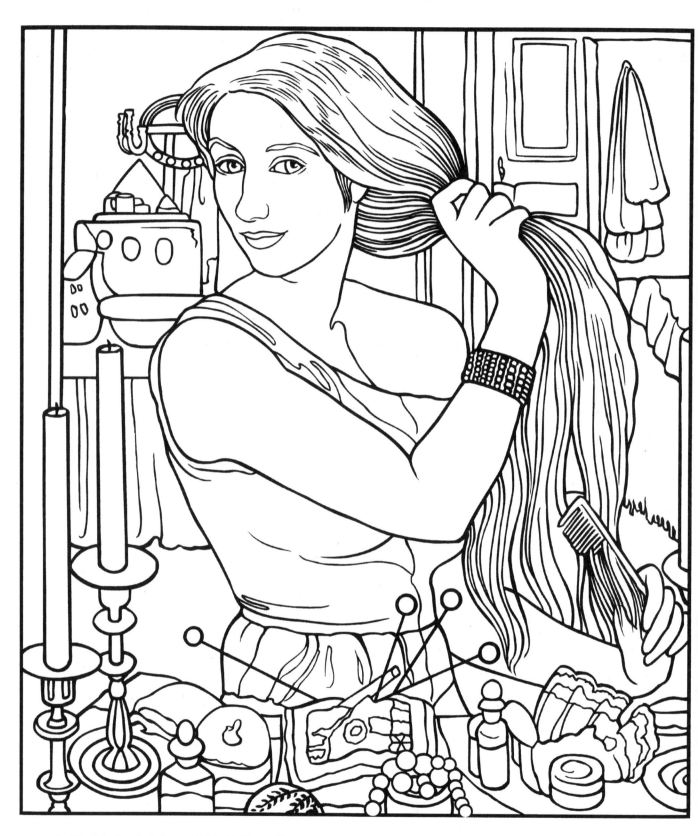

26. **Zinaida Serebriakova** (1884–1967). *Self-Portrait at the Dressing Table,* 1909. Oil on canvas. 29½ in. x 25⁹⁄₁₆ in.

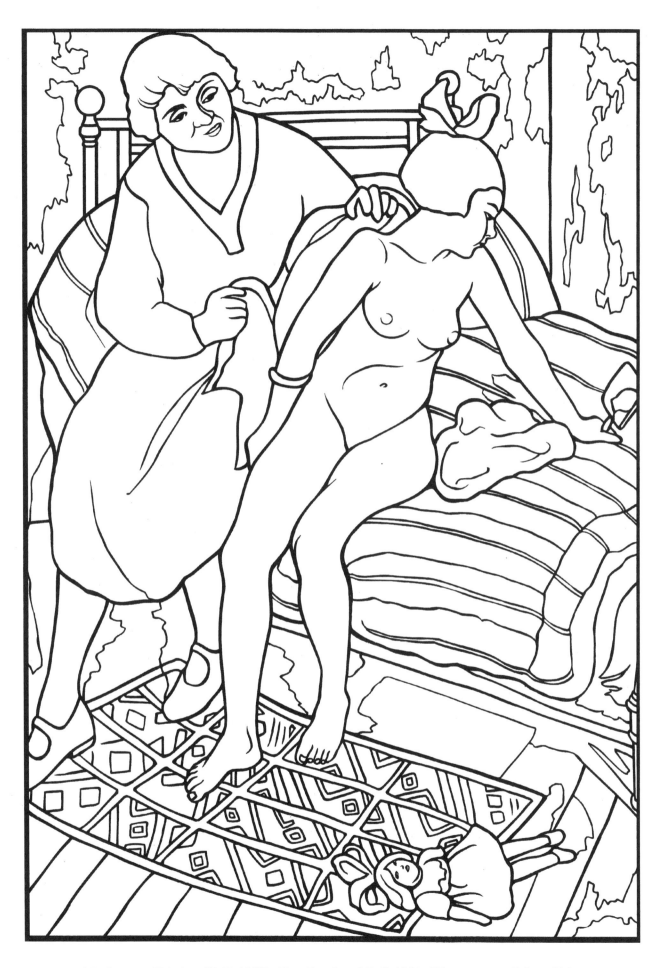

27. **Suzanne Valadon** (1865–1938). *The Abandoned Doll,* 1921. Oil on canvas. 51 in. x 32 in.

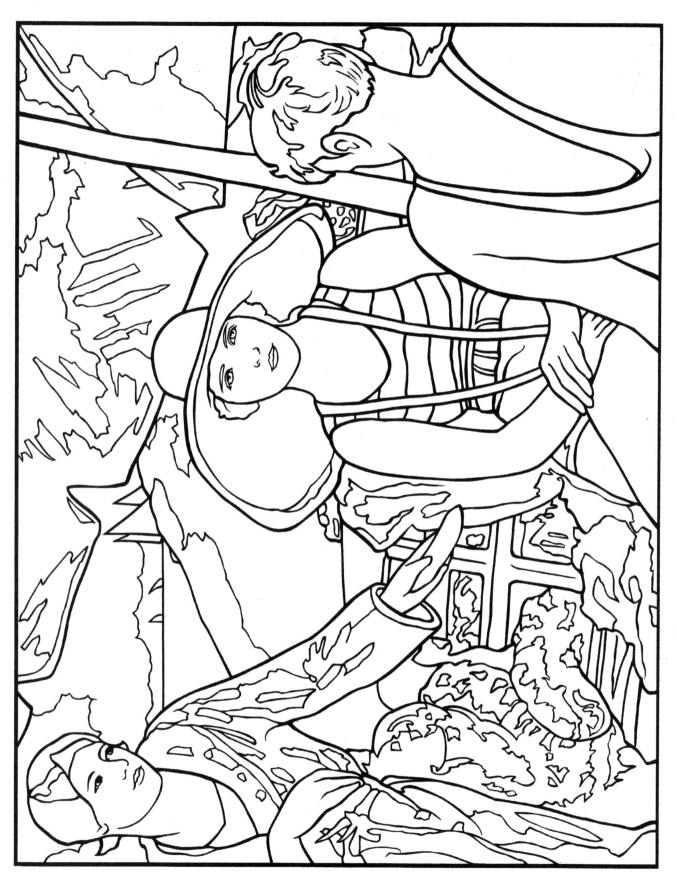

28. **Beatrice Whitney Van Ness** (1888–1981). *Summer Sunlight*, ca. 1936. Oil on canvas. 39 in. x 49 in.

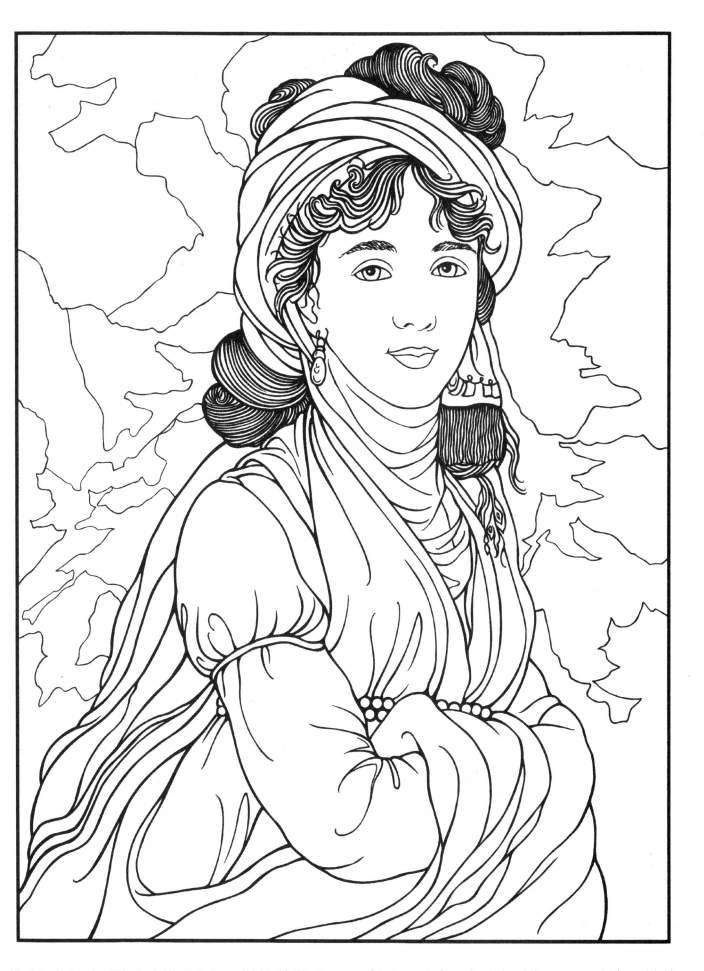

29. **Marie-Louise-Elisabeth Vigée-Lebrun** (1755–1842). *Portrait of Princess Belozersky*, 1798. Oil on canvas. 31 in. x 26¼ in.

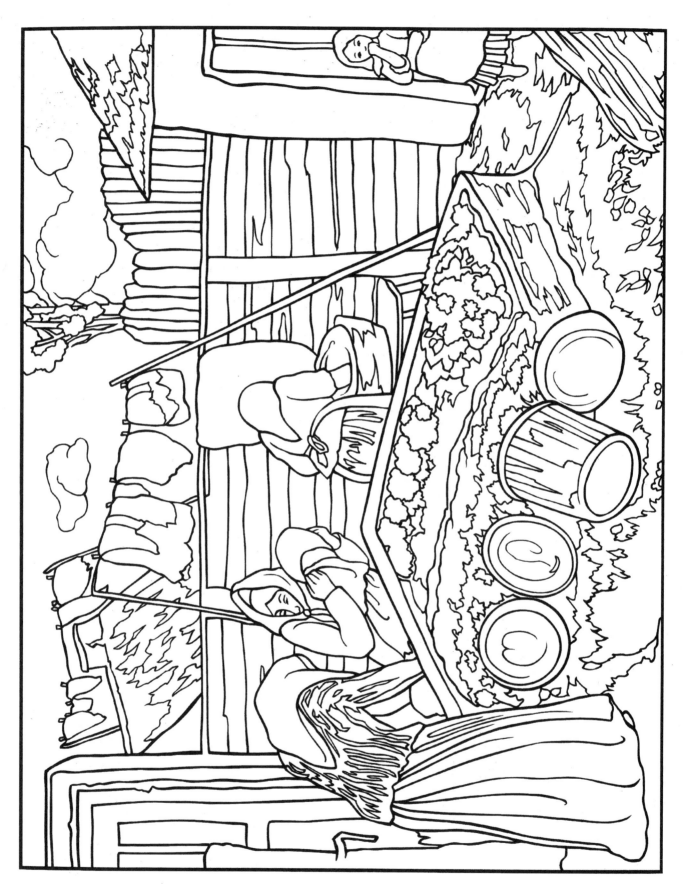

30. **Marianne von Werefkin** (1860–1938). *Washerwoman*, 1909. Tempera on paper. 19⅞ in. x 25¼ in.